MW00618218

great expectations

great expectations

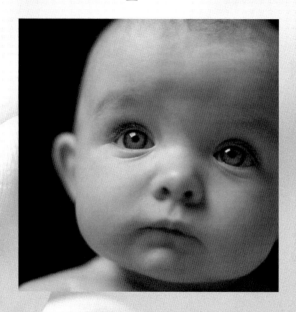

meaningful quotes on having a baby

edited by tom burns

BARRON'S

First edition for North America published 2005
by Barron's Educational Series, Inc.

© 2005 Axis Publishing Limited

All rights reserved. No part of this book may be reproduced in any form,
by photostat, microfilm, xerography, or any other means, or incorporated
into any information retrieval system, electronic or mechanical, without the
written permission of the copyright owner.

All inquiries should be addressed to:
Barron's Educational Series, Inc.
250 Wireless Boulevard
Hauppauge, New York 11788
www.barronseduc.com

Library of Congress Catalog Card No: 2004118226

ISBN 13: 978-0-7641-5879-7
ISBN 10: 0-7641-5879-1

Conceived and created by
Axis Publishing Limited
8c Accommodation Road
London NW11 8ED
www.axispublishing.co.uk

Creative Director: Siân Keogh
Designer: Simon de Lotz
Editorial Director: Anne Yelland
Production Manager: Jo Ryan

Printed and bound in China

9 8 7 6 5 4 3 2 1

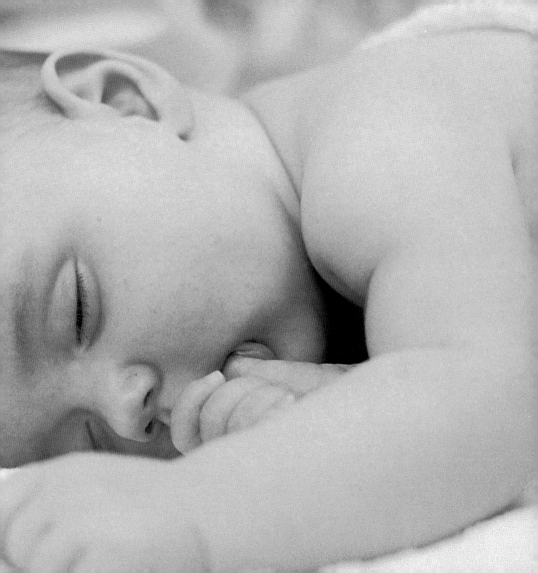

about this book

Babies make the world wonderful and waiting for their baby to be born is a special time in the lives of most parents. *Great Expectations* brings together an inspirational selection of powerful and life-affirming phrases about babies and small children and combines them with evocative photographs that bring out the full richness of our relationships with our children.

We sometimes forget to enjoy the wonder of our friends' pregnancy, concentrating instead on when the baby is born. But pregnancy is a time of wonder, a time to tell our friends how much they will love their baby and how we will be there to offer our support through the good and bad times in our lives.

These inspiring examples of wisdom, distilled from true-life reflections of people from many walks of life, sum up the essence of why our children will always have a unique place in our hearts.

about the author

Tom Burns has written for a range of magazines and edited more than a hundred books on subjects as diverse as games and sports, cinema, history, and health and fitness. From the many hundreds of contributions that were sent to him by people from all walks of life, he has selected the ones that best sum up the special place reserved for babies and small children in our hearts.

Please continue to send in your views, feelings, and advice about life—you never know, you too might see your words of wisdom in print one day!

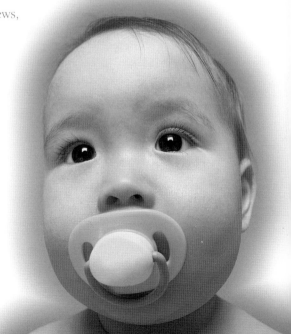

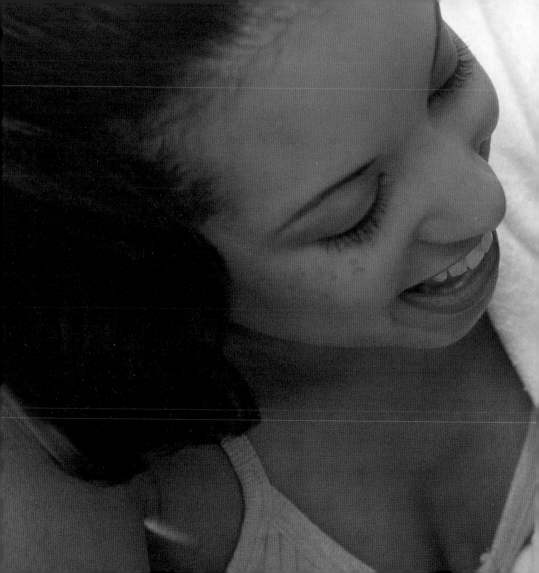

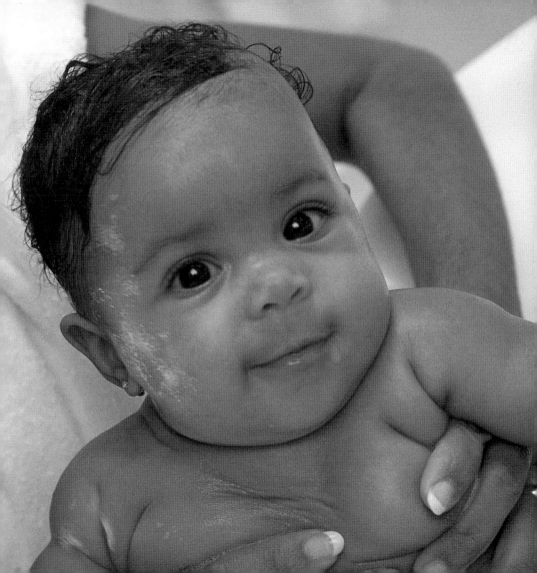

Deciding to have a baby
is choosing to wear your heart
on the outside.

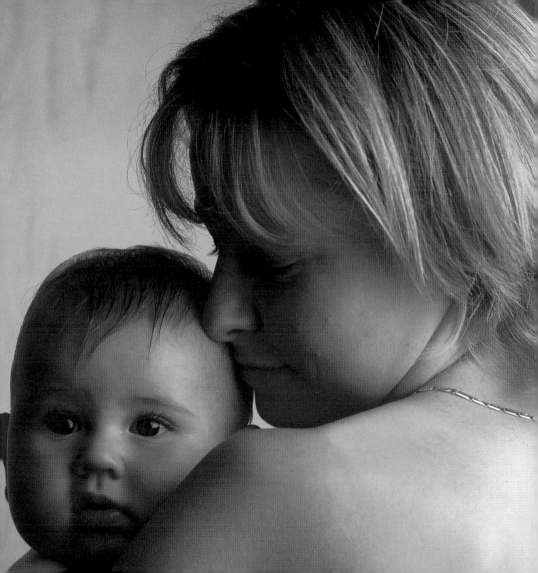

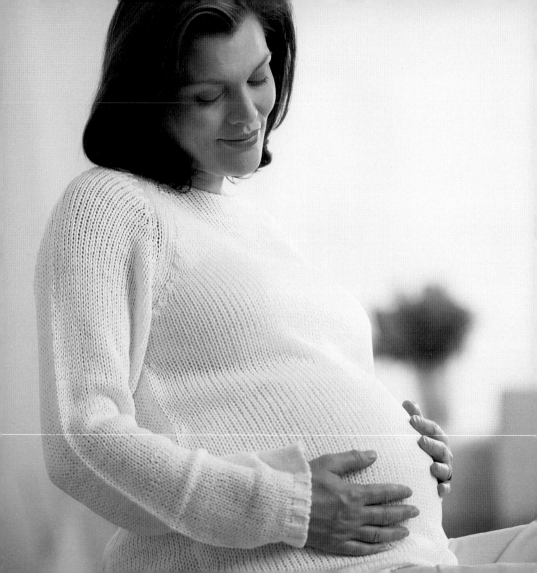

Life is largely a matter
of expectation.

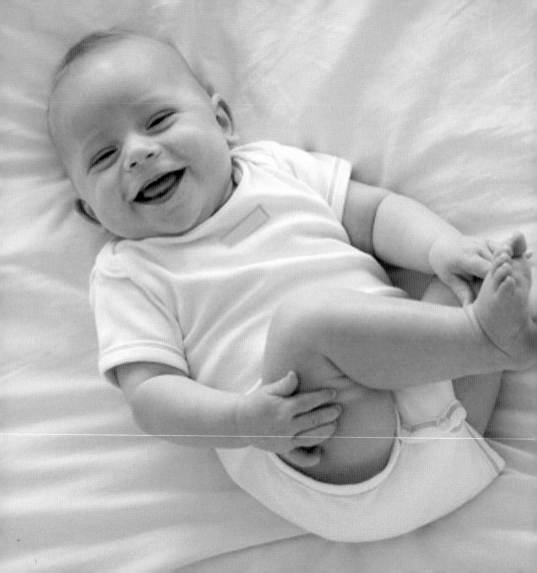

Good is not good when
the best is expected.

Nobody's perfect, but a sleeping baby comes close.

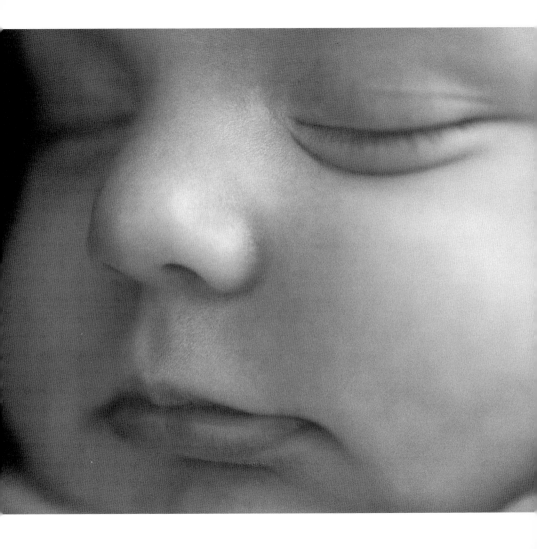

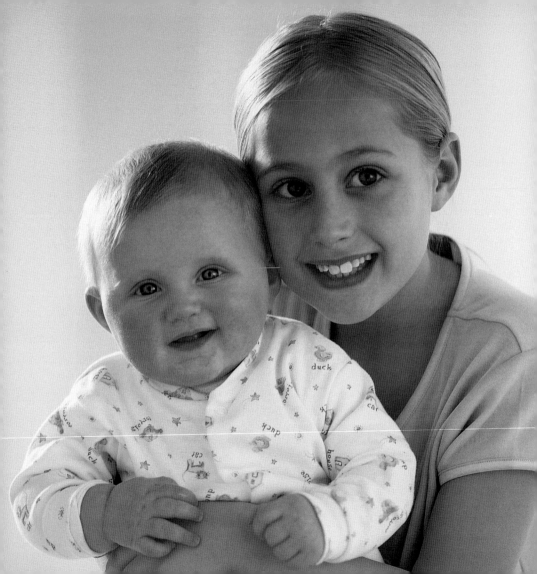

Sisters share the same language.

A birth brightens the
world as if a second sun
has come out.

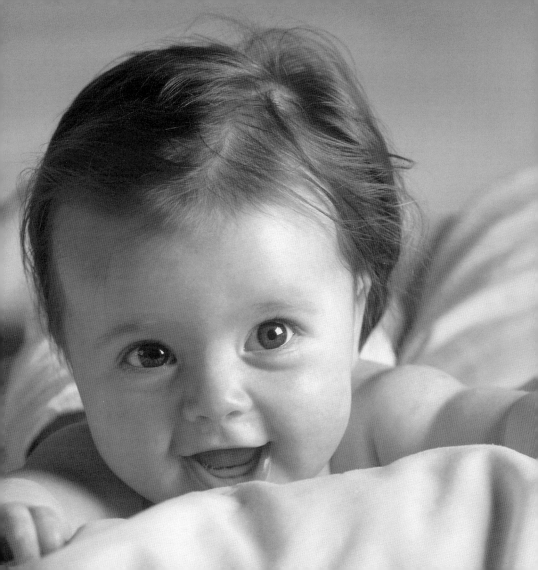

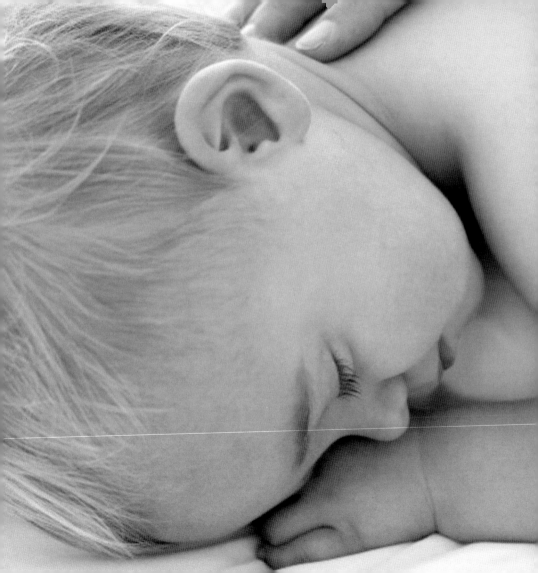

A baby is an angel whose wings
decrease as his legs increase.

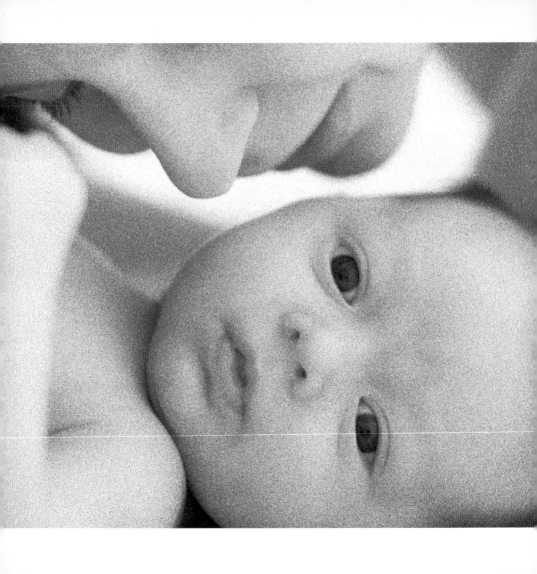

A star danced,
and I was born.

Babies make love stronger.

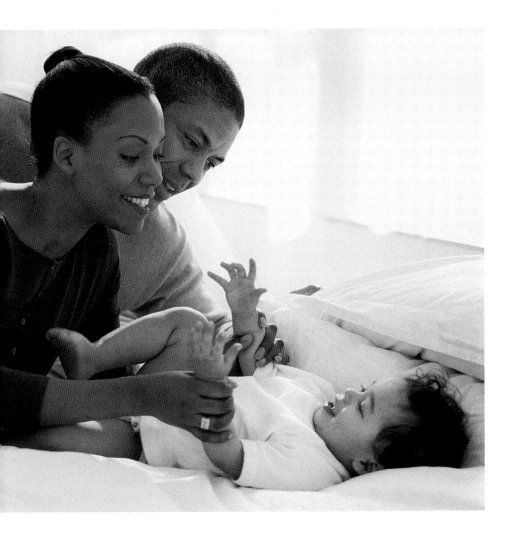

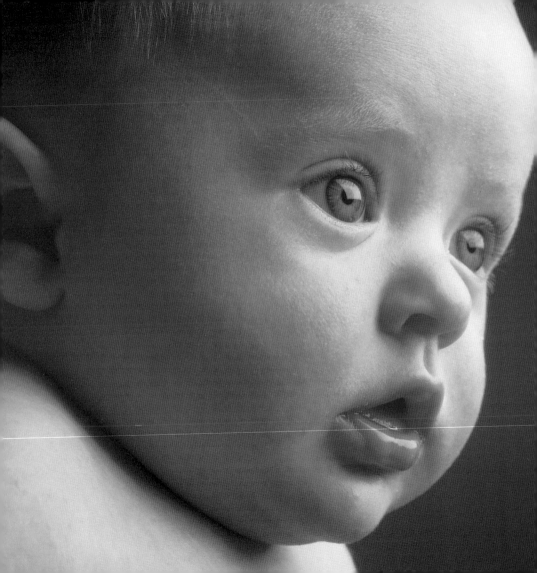

A new baby is the
beginning of all things…

…hope, wonder,
dreams, and possibilities.

Children are the keys to paradise.

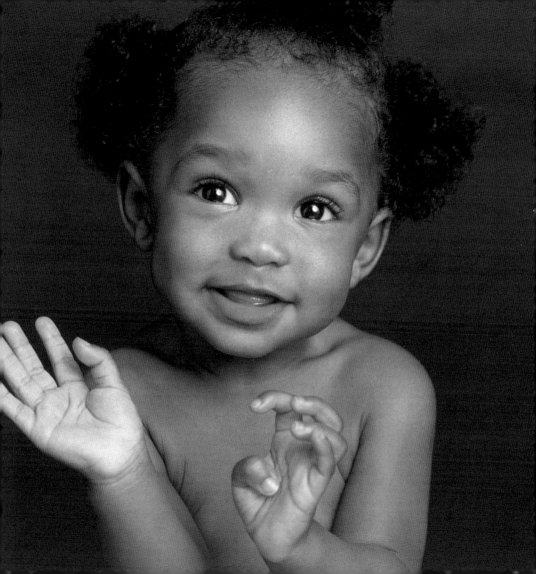

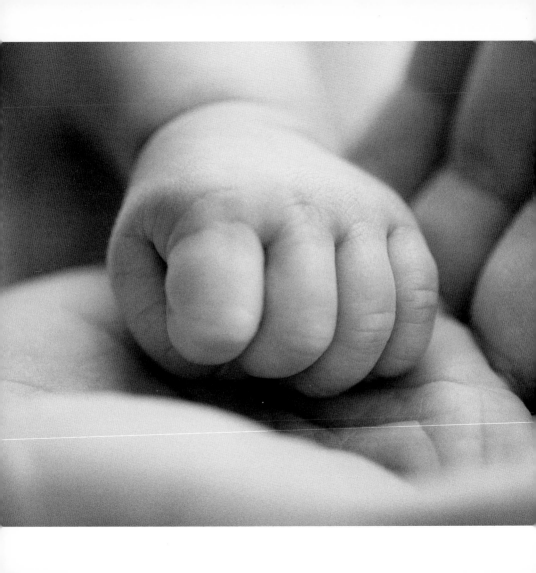

Babies are bits of
star-dust blown
from the hand of God.

A baby is the incarnation
of perfect love.

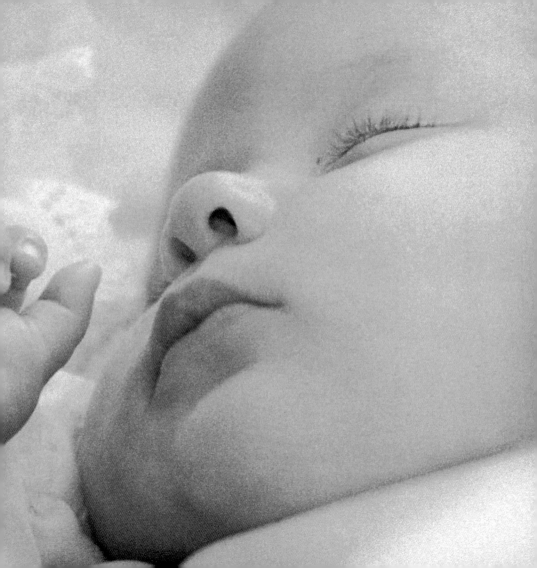

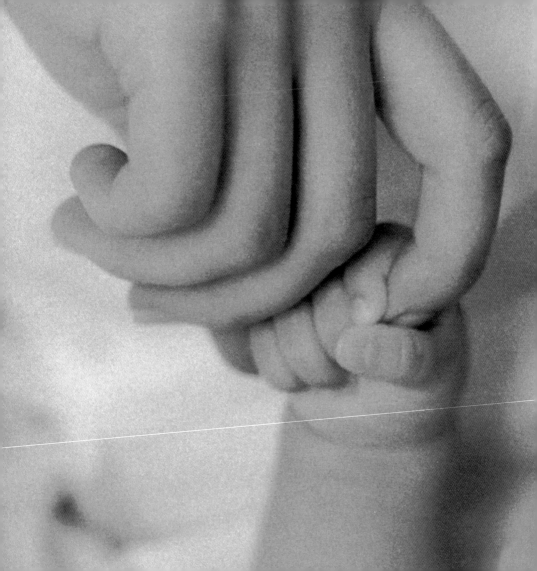

Being around small children heals the soul.

A mother is born
when her baby is born…

…before that she
is simply a woman.

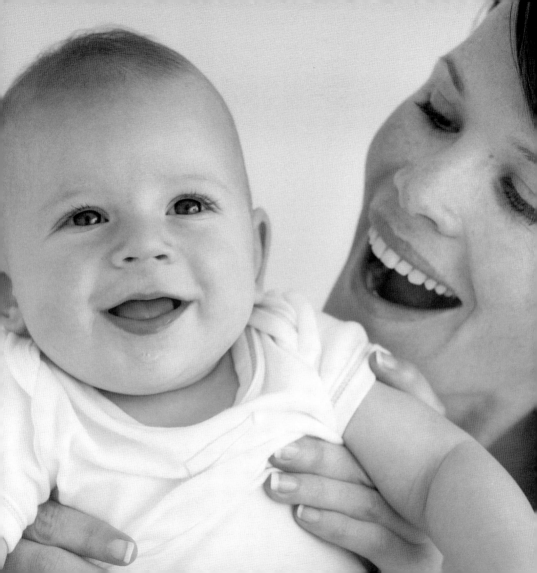

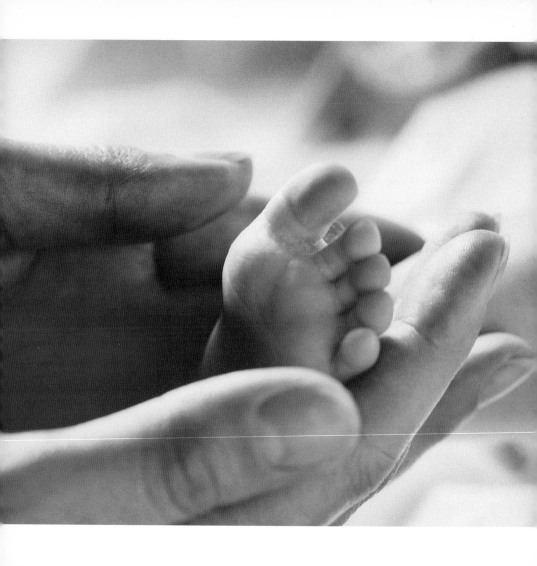

A mother's love enables
a normal human being to
do the impossible.

Your family is a gift to you.

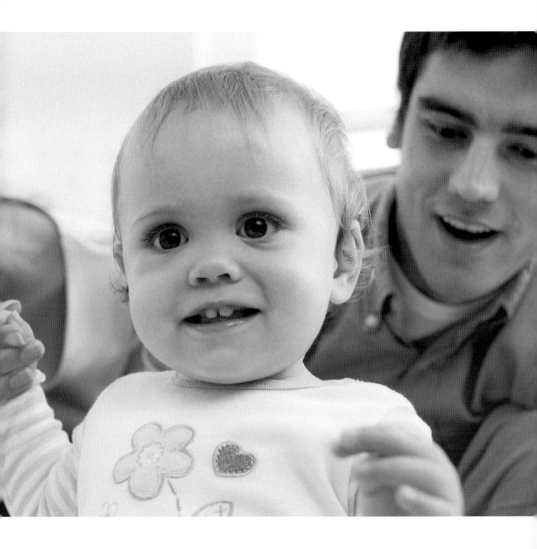

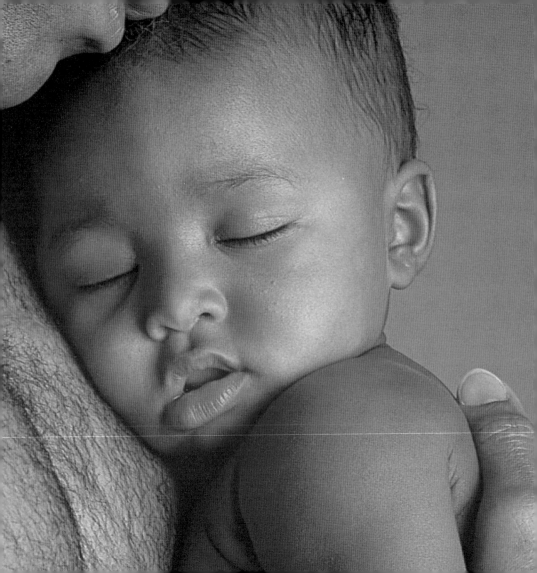

Holding a new baby is a reminder that no problem in the world is too big to be remembered.

To understand your parents' love you must raise a child yourself.

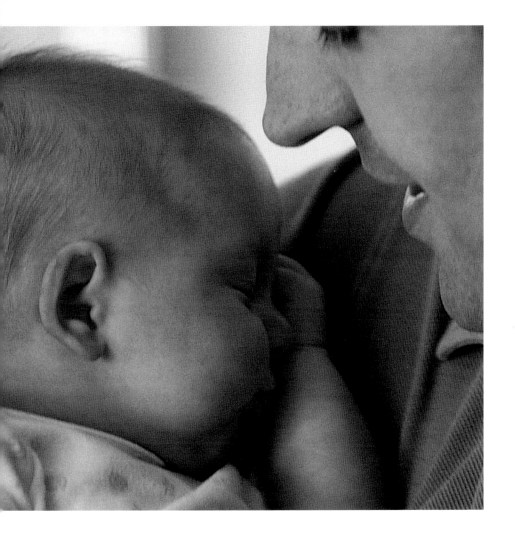

A mother's arms are made of tenderness.

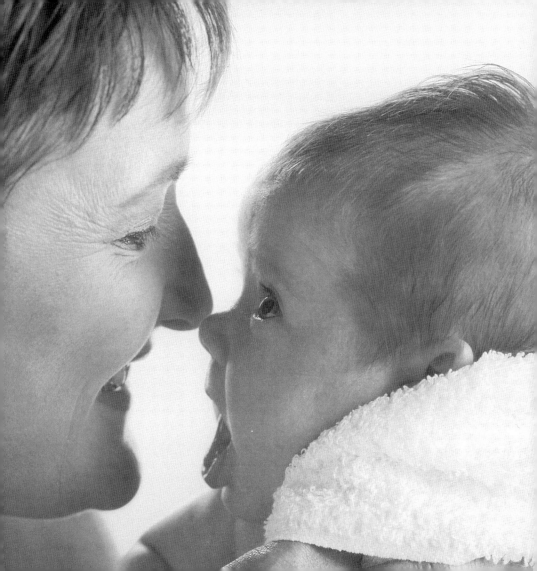

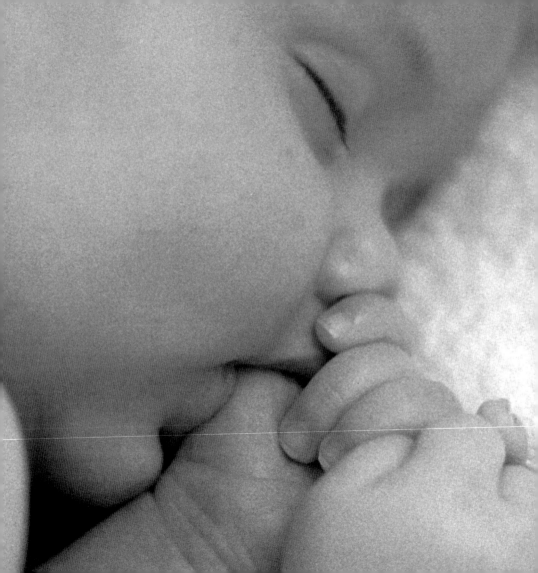

A baby is an angel in disguise.

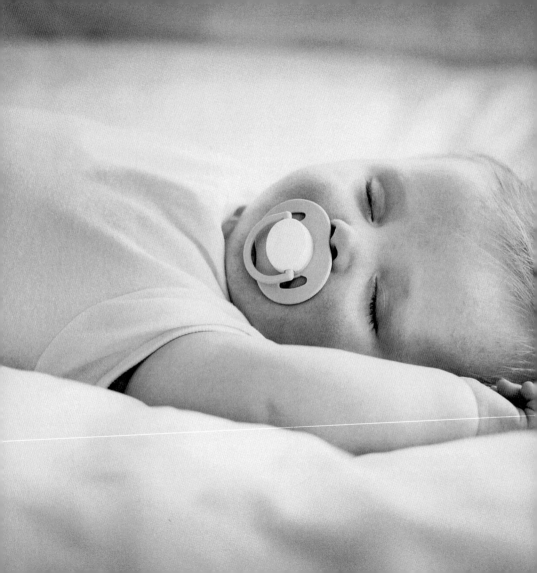

The best is always
yet to come.

A baby is a messenger
of love and peace.

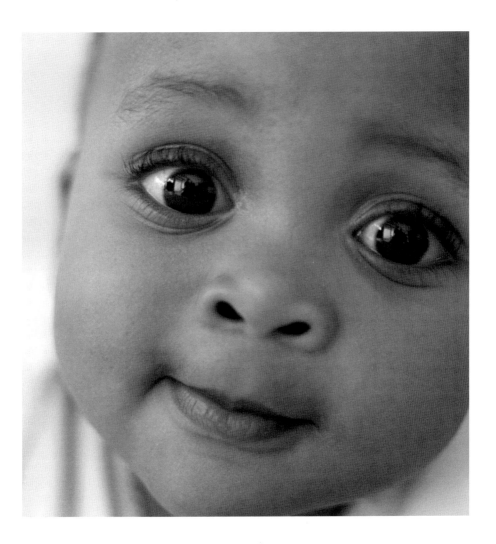

The best of life's
treasures is a baby.

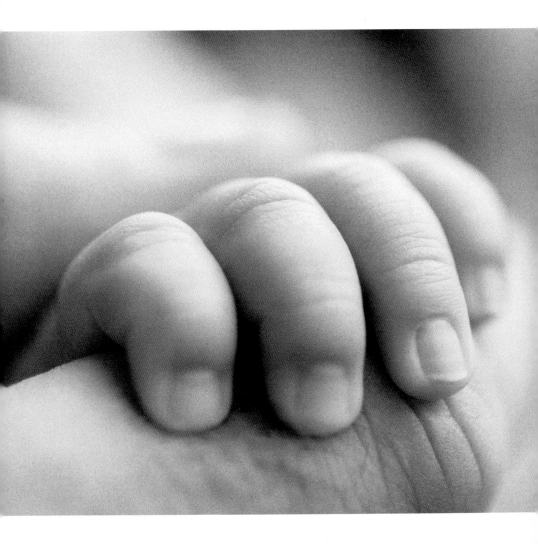

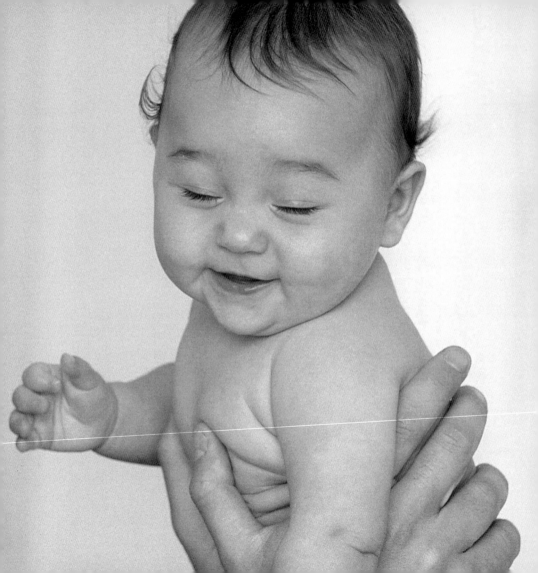

Babies were made
to be cuddled.

A smile is a light in the
window of the soul
indicating that the
heart is at home.

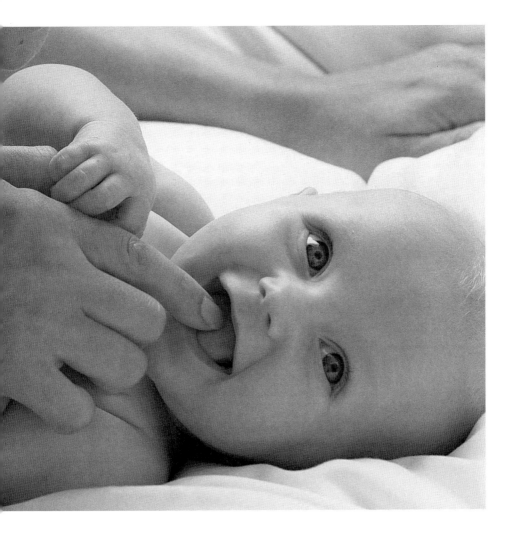

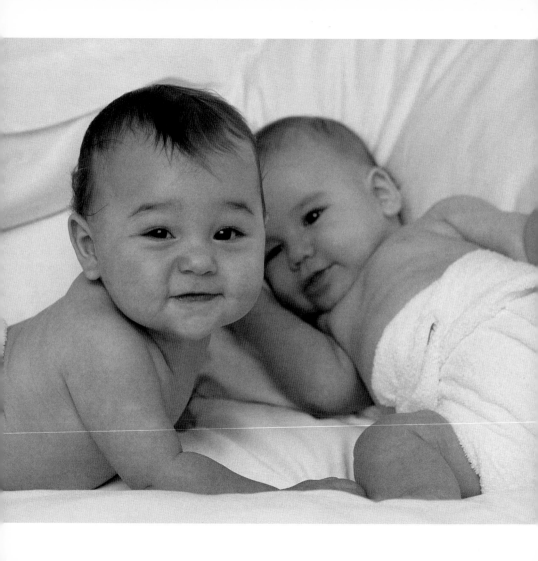

All babies smile in the
same language.

Babies are such nice ways to start people.

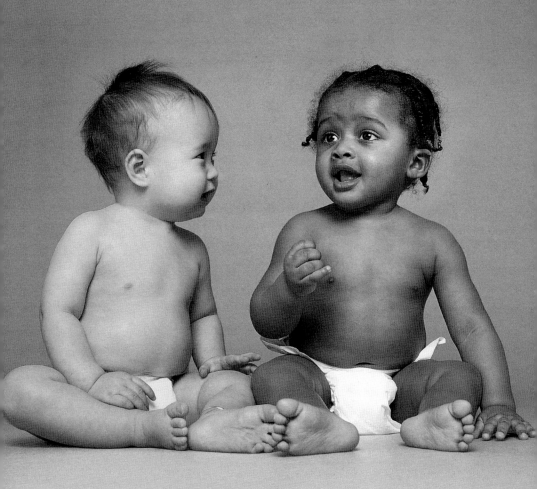

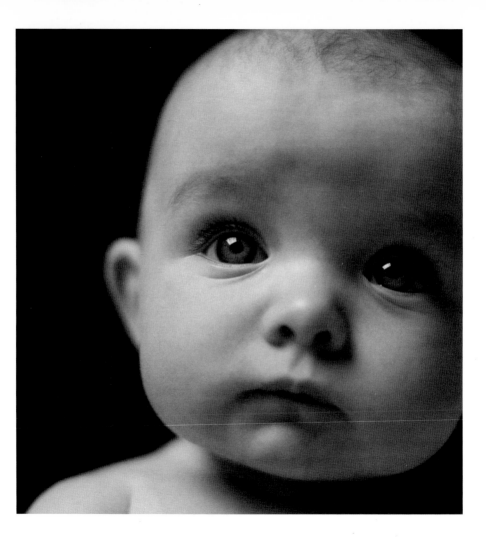

A baby fills a hole in your heart
which you never knew existed.

The future is always worth living for when you have a new baby.

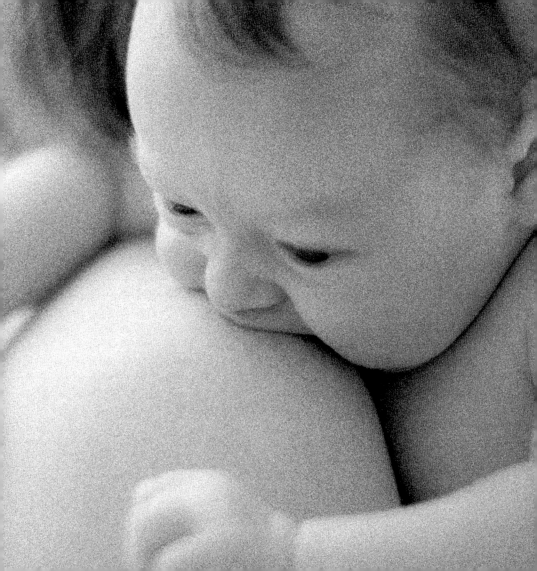

Babies are always more
wonderful than you
imagined they would be.

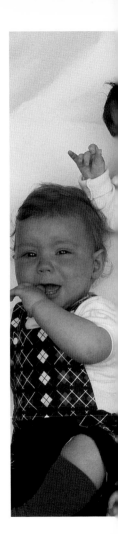

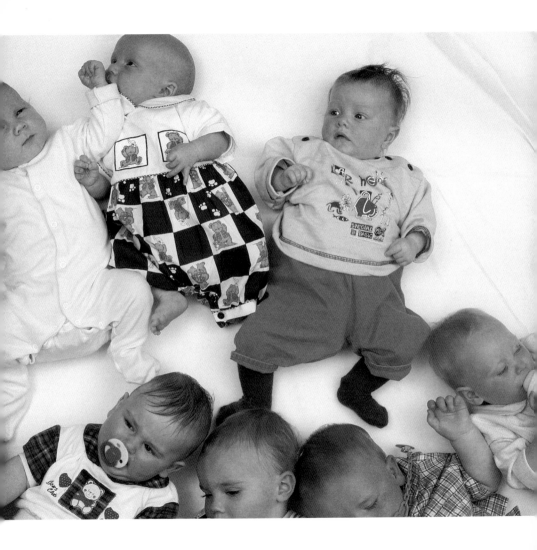

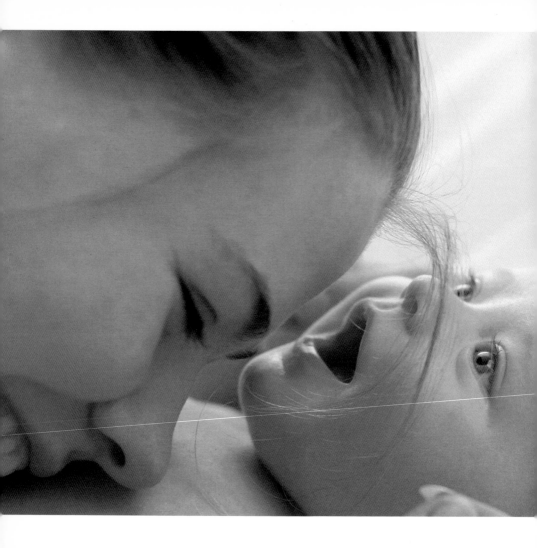

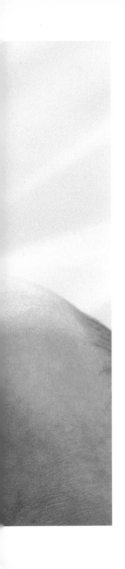

A baby never outgrows
its need to be loved.

Children need problems
to solve, not answers
to remember.

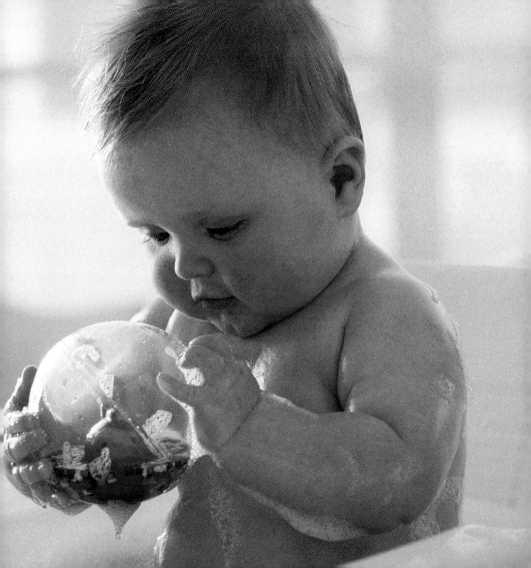

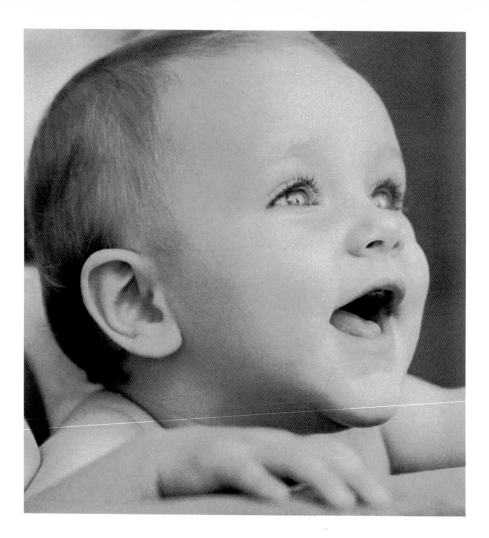

Babies are kisses blown
to us by angels.

Children who live with praise
learn appreciation.

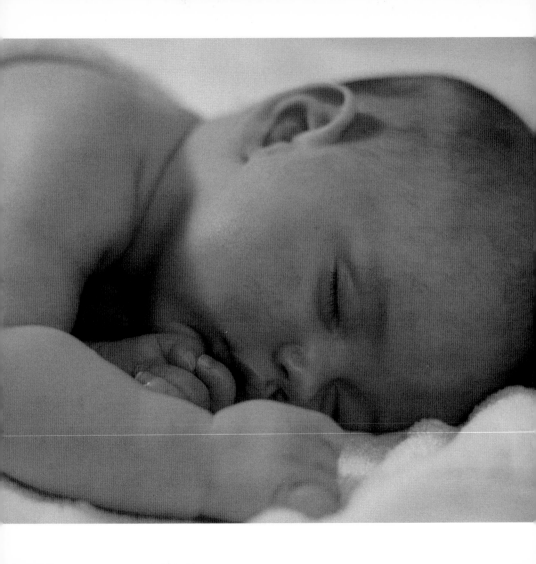

The world shines bright
with endless possibilities
each time a baby is born.

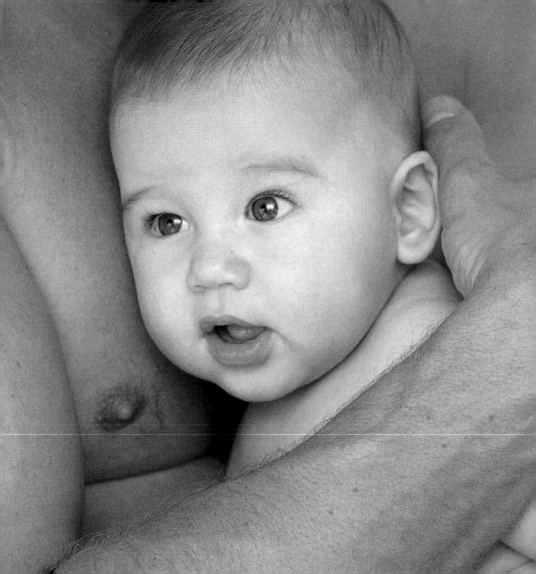

After love, a baby needs two things from you…

…roots and wings.

Where children are,
there is the golden age.

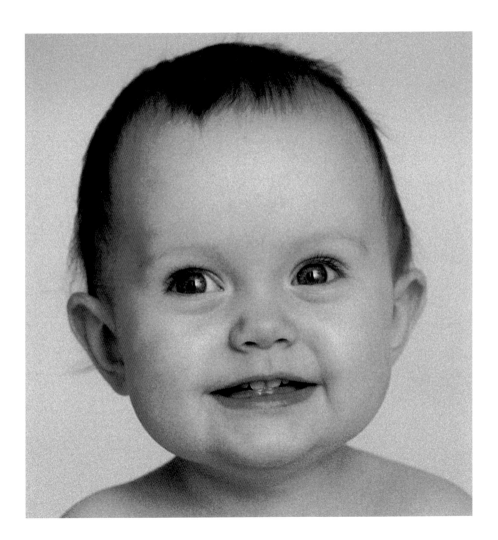

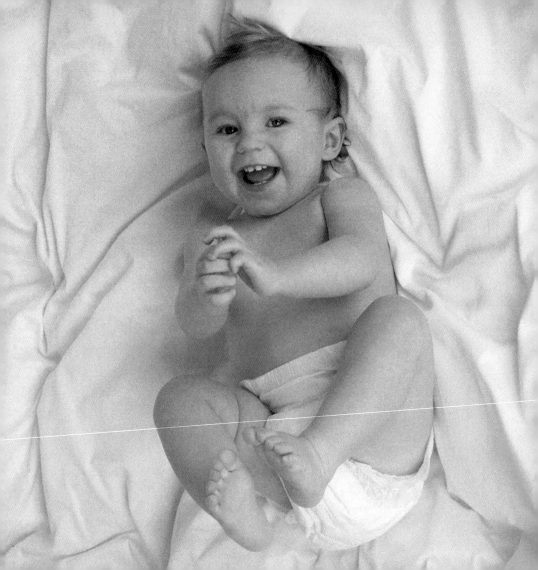

A day without laughter
is a wasted day.

Children are our future.

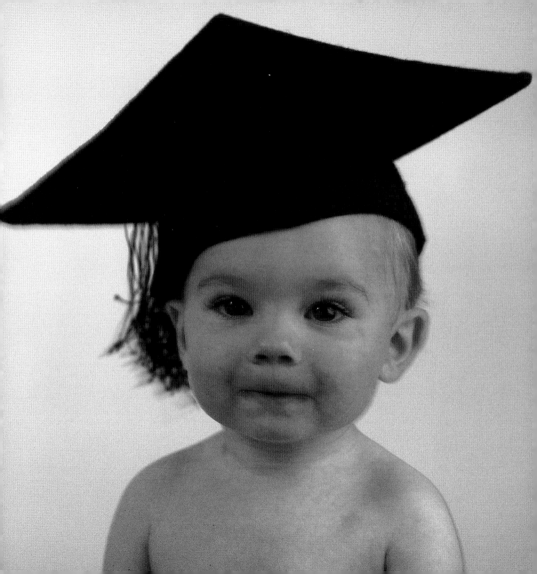

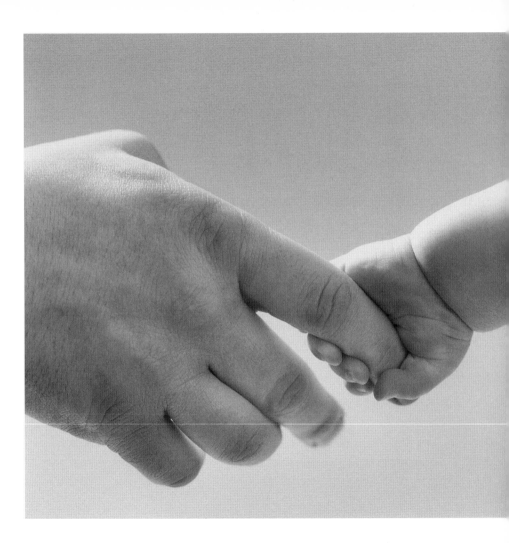

Reach for the stars,
so your children
will do the same.

Enjoy your children now…

…the film of childhood
cannot be rewound.

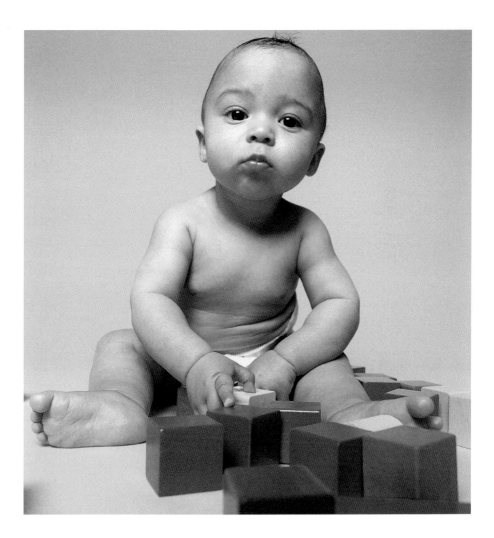

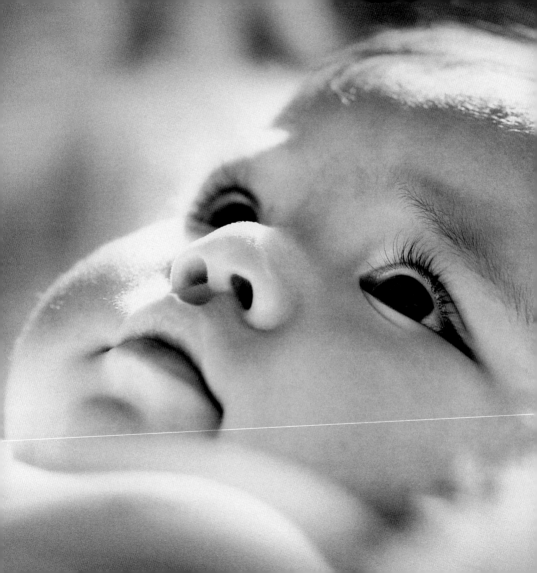

There is one pretty child
in the world and every
mother has it.

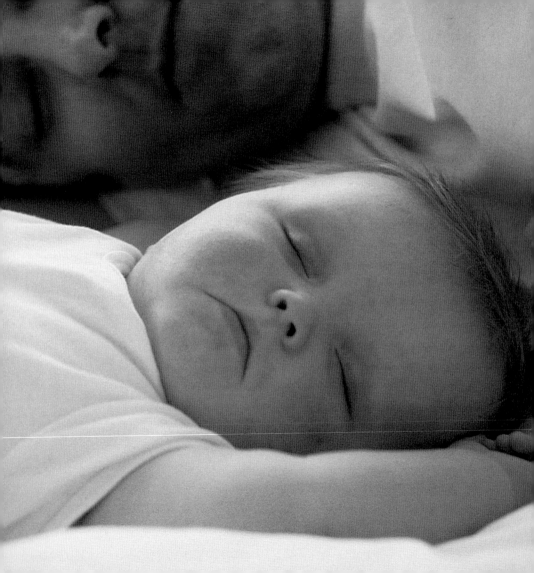

When a moonbeam touched a cloud, a sleeping baby's smile was born.

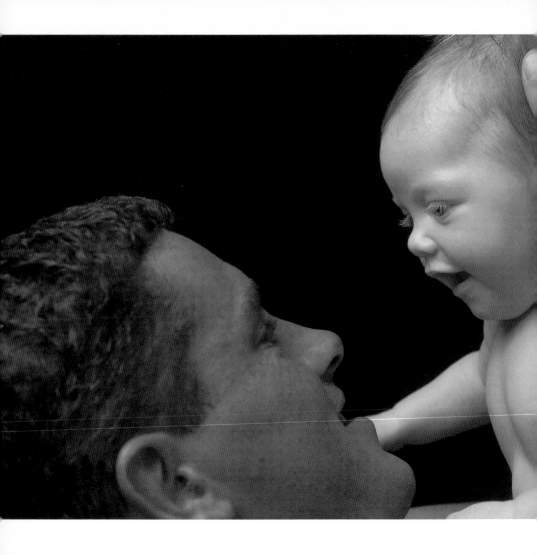

You have a lifetime to work, but your children are only young once.

A child can ask questions that
a wise man cannot answer.

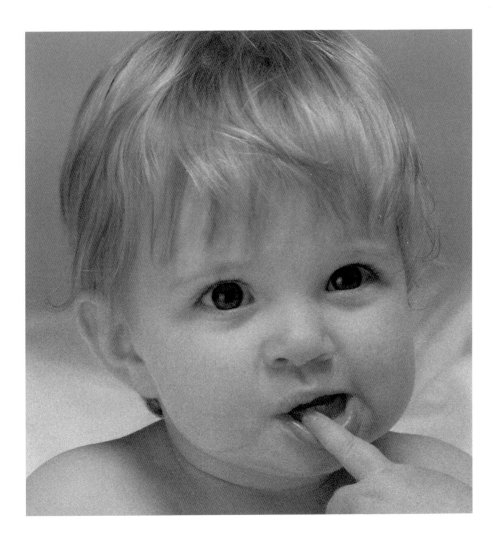

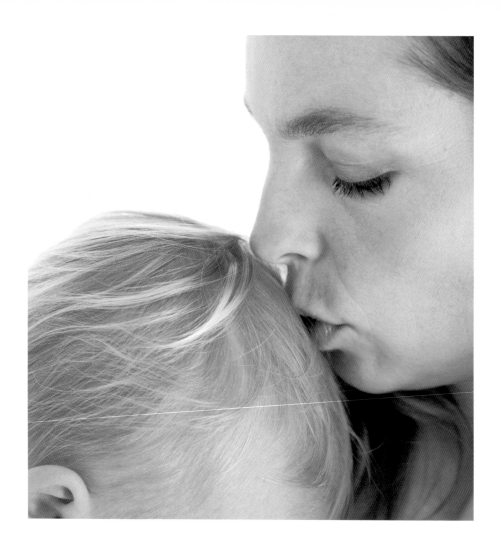

A child's character is built
by its mother, who sways
a scepter more potent than
that of kings or priests.

Children are living jewels
dropped from heaven.

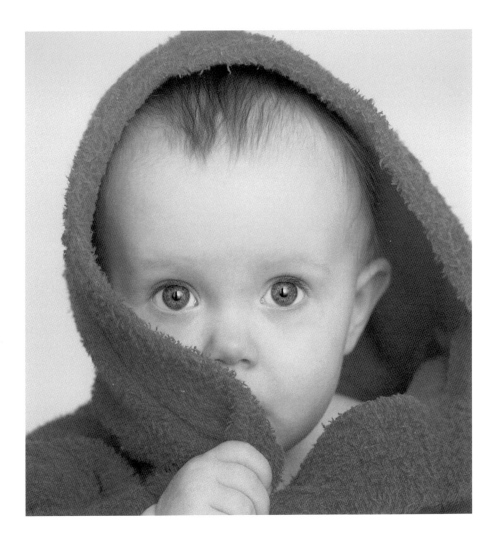

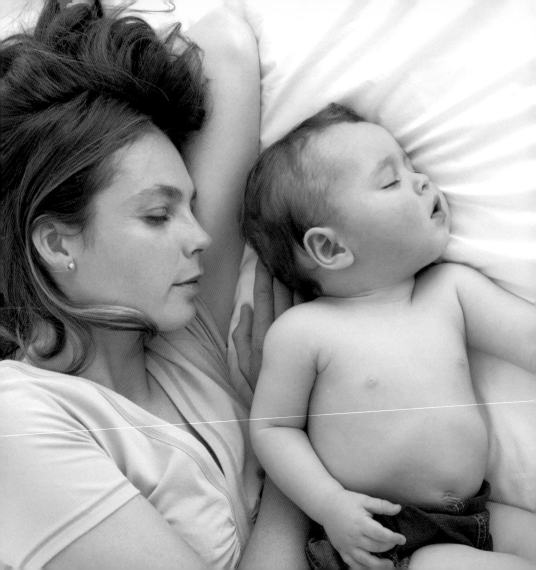

Children make their
parents immortal.

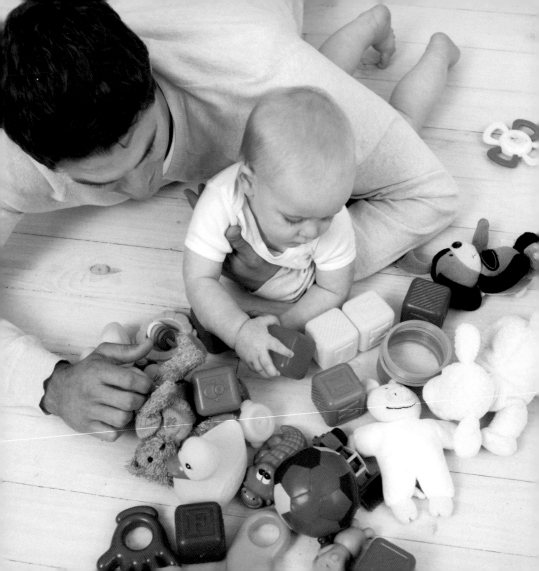

Teaching a child well is an investment in the future.

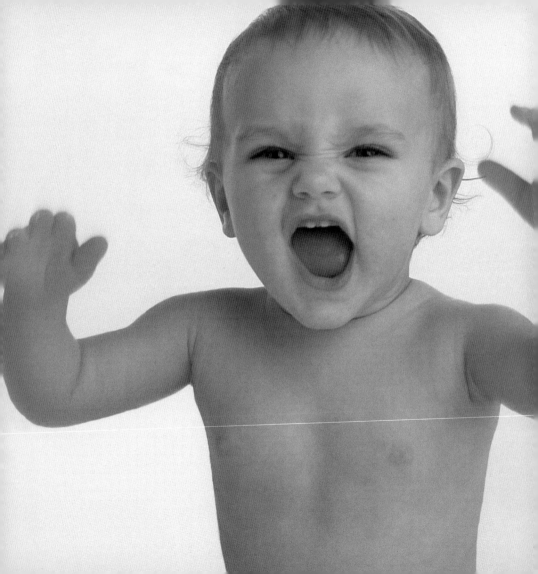

Don't worry what a child
will be tomorrow…

…remember what
he is today.

God believes that the
world should go on:
that's why he
created babies.

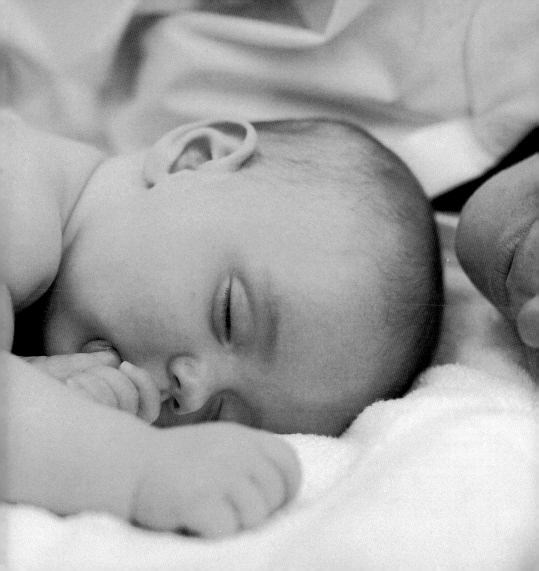

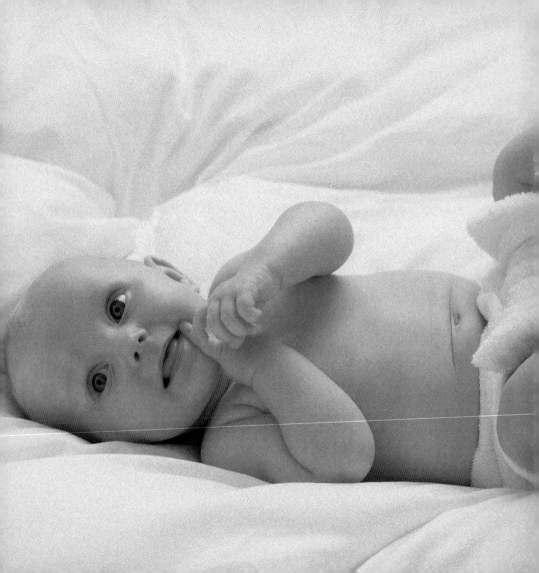

A child is a beam
of sunlight.

The best way to keep your children is to let them go.

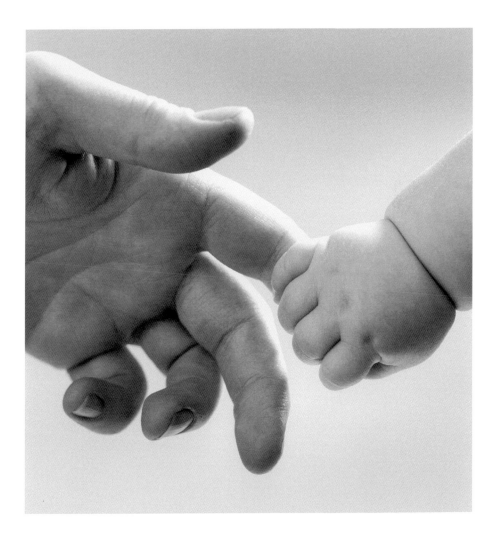

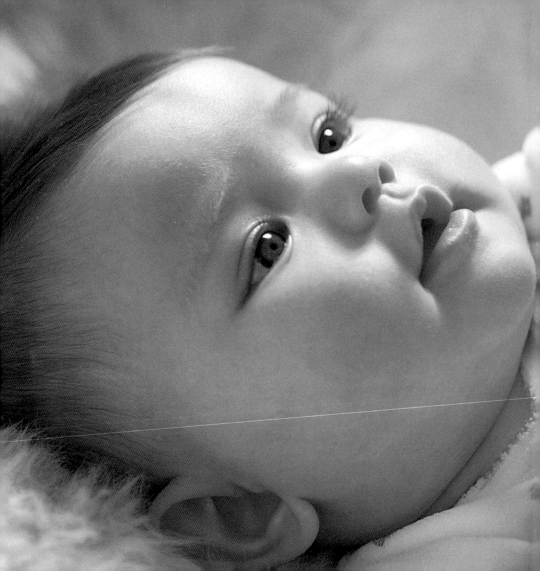

If your children look
up to you, you've
made a success of
life's biggest job.

Children are more valuable than even the wealthiest man's riches.

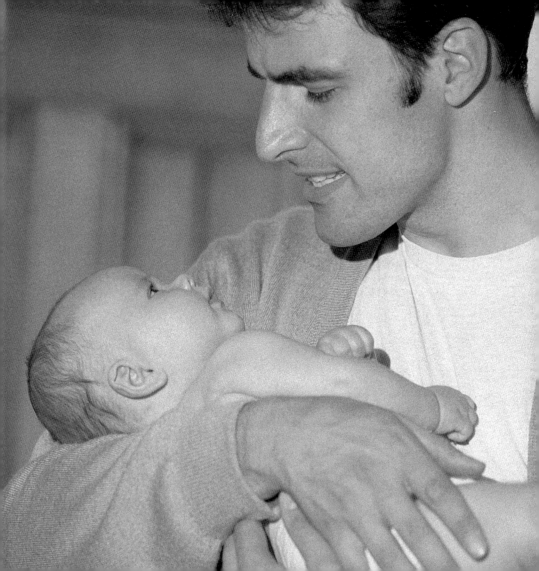

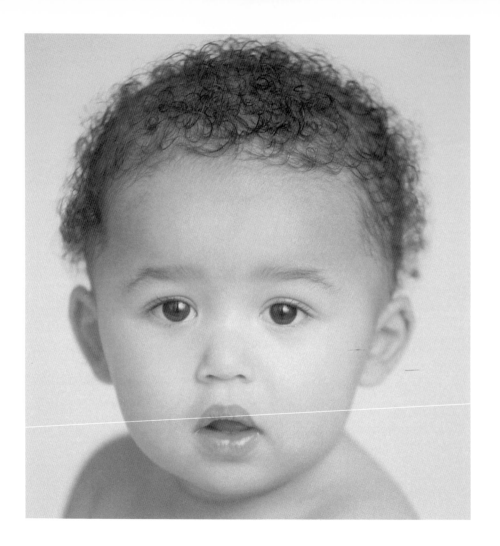

Don't be discouraged if your children reject your advice. Years later they will offer it to their own children.

Raising the next generation
of children is a privilege.

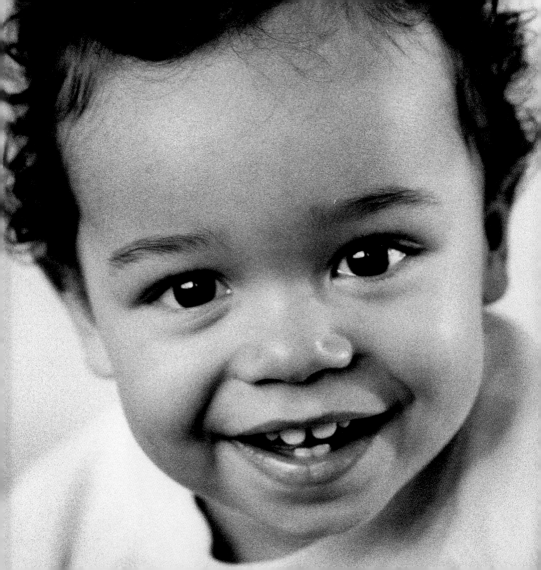

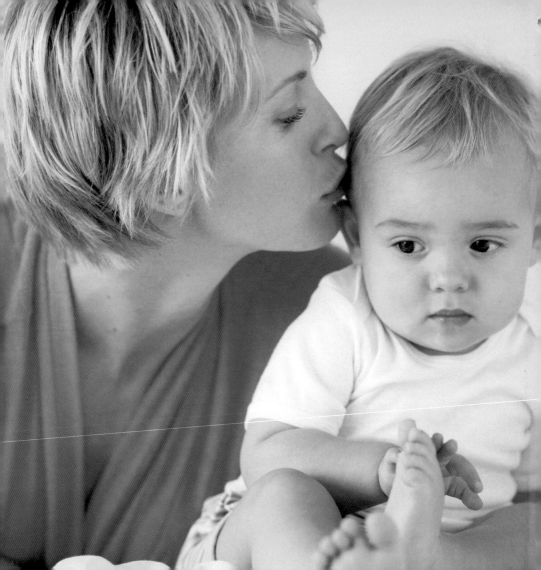